What You Need

BEFORE YOU START DRAWING, YOU WILL NEED A FEW THINGS!

Drawing Paper

There is probably too many options to choose from when it comes to drawing paper, so we recommend starting with simple plain white paper. This way you can control your pencil strokes. Thicker paper will allow you to erase more often.

Pencils

You may think there is only one kind of pencil, but there's actually lots to choose from.

The pencil sets range from 9H (hard) to 9B (soft). Pencils ranging in HB are in the middle.

Hard pencils are perfect for sketching light, thin lines. Whereas soft pencils are better for shading and adding some texture as well as creating heavier and darker strokes.

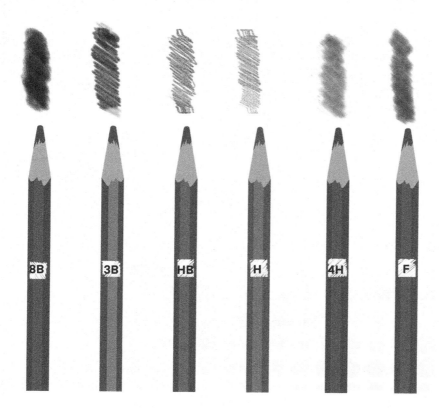

How to hold a pencil

There are two ways. Holding the pencil closer to the end of the tip gives you more control and allows you to create heavier strokes. Gripping it from the end gives you less control, but creates lighter strokes.

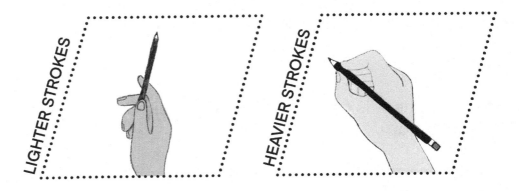

YOU WILL ALSO NEED:

- A COMPASS FOR DRAWING ROUND THINGS

- A TRIANGLE SET TOOL

- A RULER FOR CREATING STRAIGHTER LINES

DON'T FORGET YOUR PENCIL SHARPENER OR A SANDPAPER BLOCK

AND OF COURSE, ERASERS!

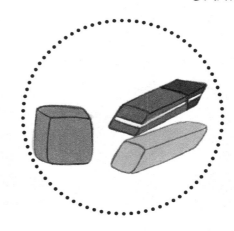

UNOFFICIAL

3 IN 1 DRAWING BOOK

HOW TO DRAW

MINECRAFTER · **ROBLOXER** · **FORTNITER**

CONTENTS

MINECRAFT

ROBLOX

FORTNITE

Techniques

LASTLY, HERE ARE SOME BASIC TECHNIQUES YOU CAN USE WITH YOUR PENCIL:

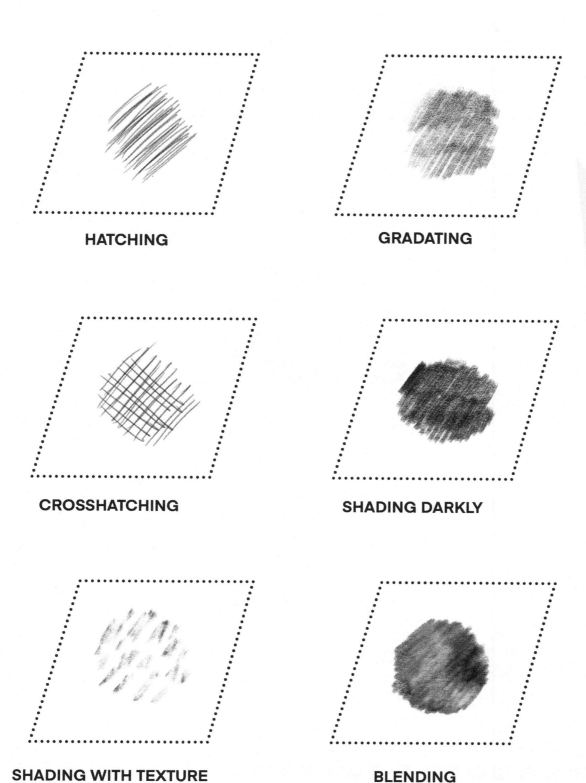

HATCHING

GRADATING

CROSSHATCHING

SHADING DARKLY

SHADING WITH TEXTURE

BLENDING

EASY

①

②

③

④

⑤

⑥

GREAT
JOB!

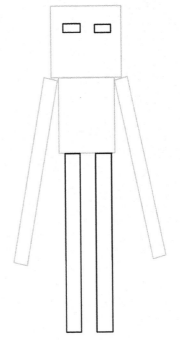

8

①

②

③

④

⑤

⑥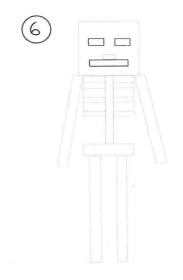

GREAT
JOB!

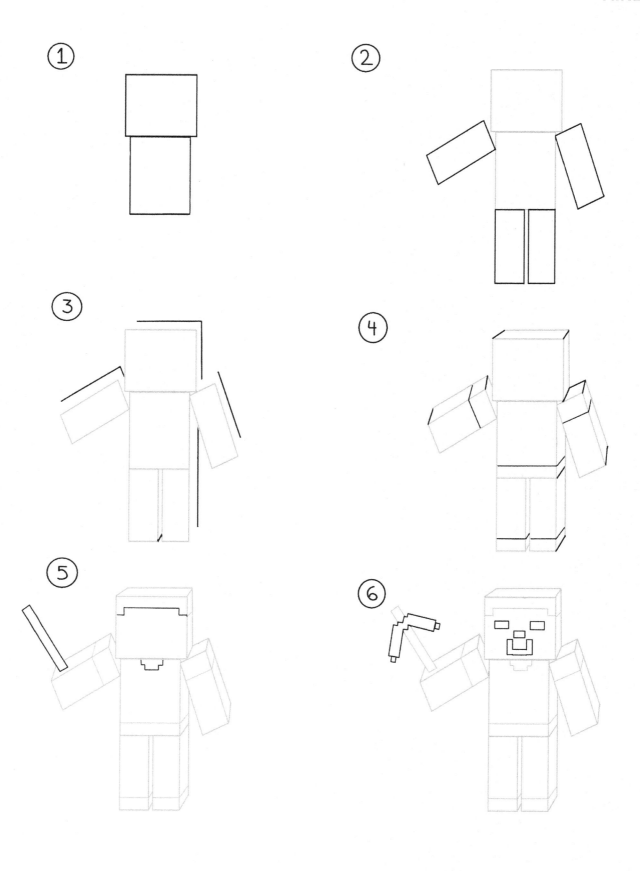

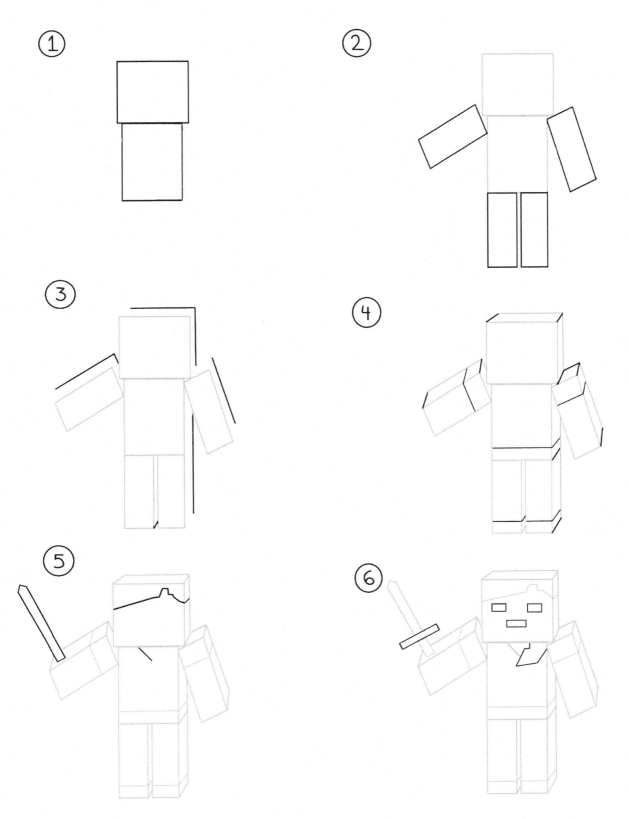

GREAT JOB!

GREAT JOB!

①

②

③

④

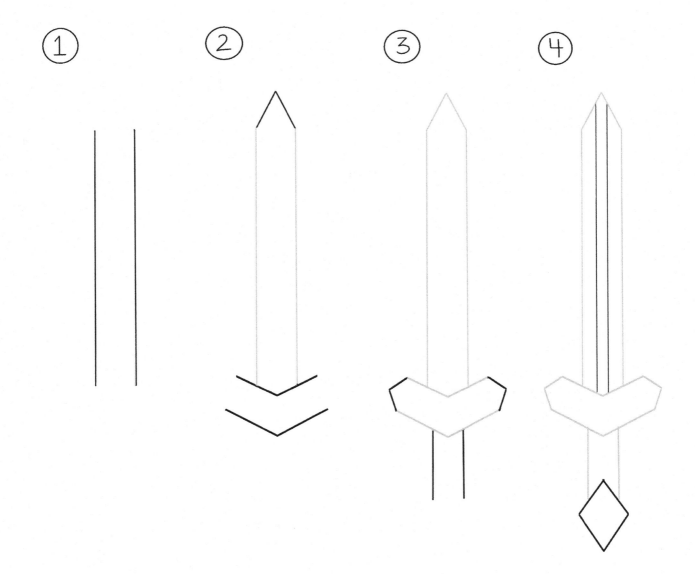

GREAT JOB!

①

②

③

④

⑤

⑥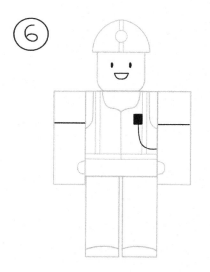

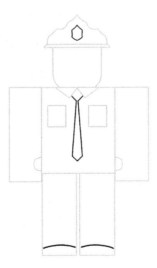

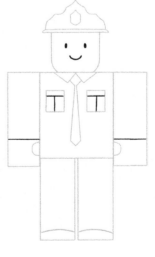

YOU
ROCK!

1

2

3

4

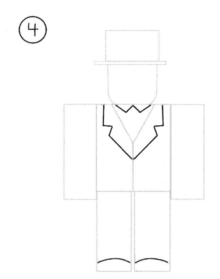

5

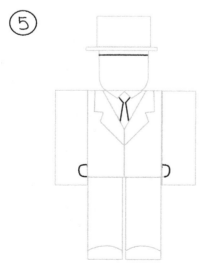

6

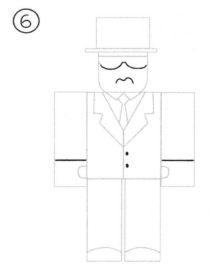

18

① ②

③ ④

⑤ ⑥

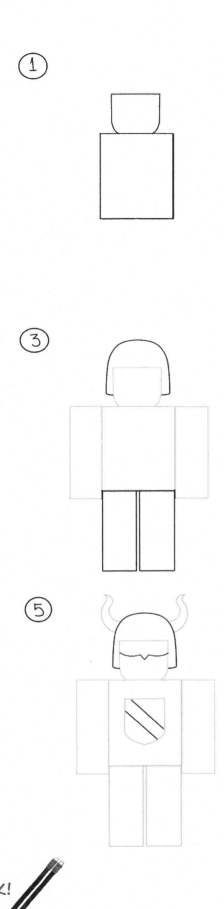

YOU
ROCK!

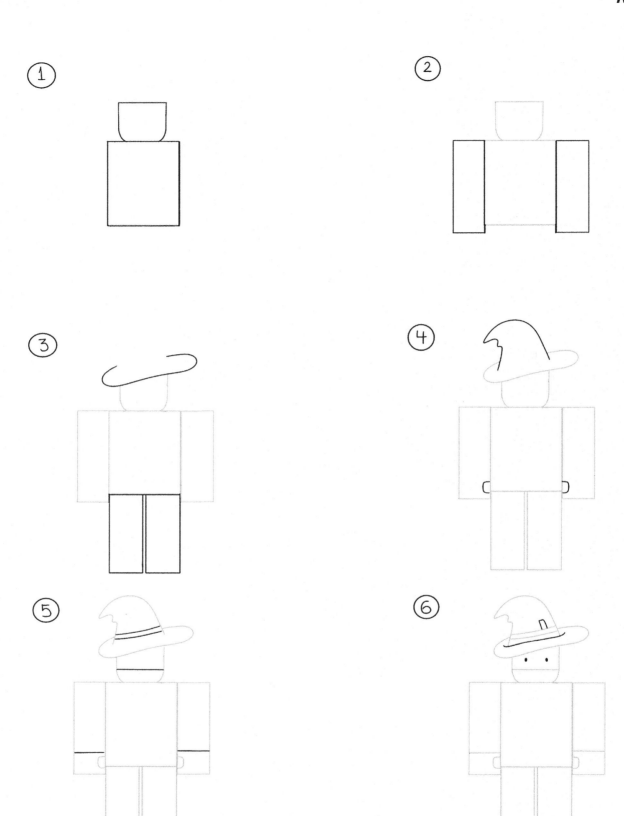

①

②

③

④

YOU ROCK!

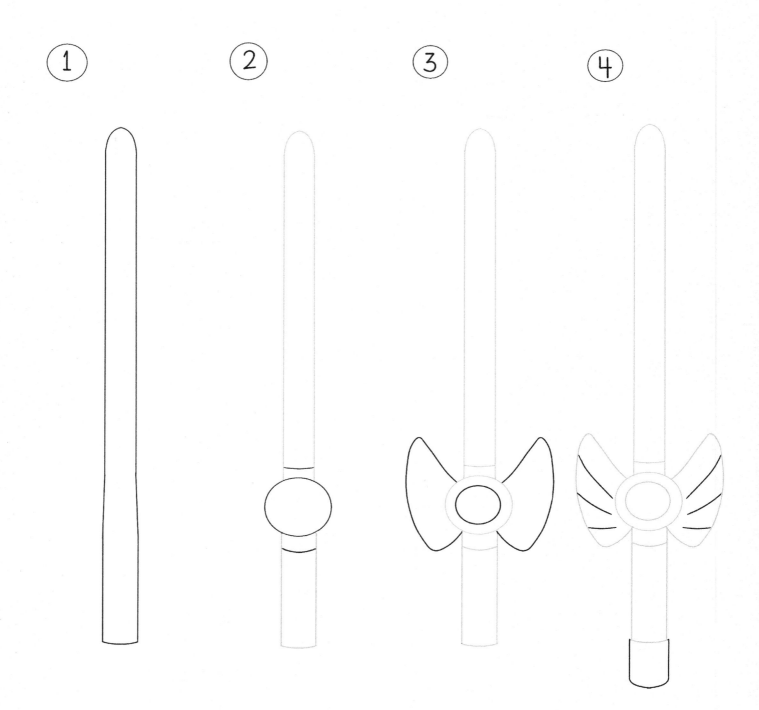

1

2

3

4

YOU
ROCK!



GREAT JOB!

①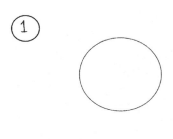

②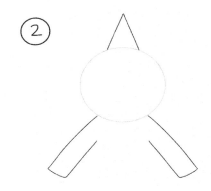

③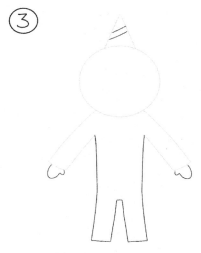

④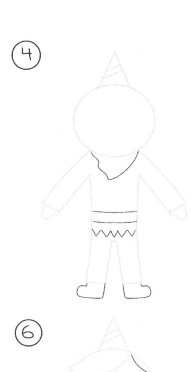

⑤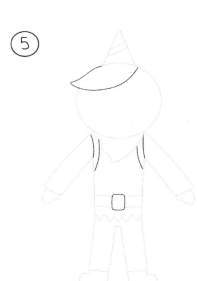

⑥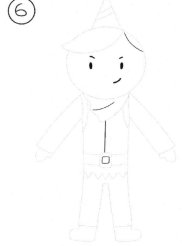

①

②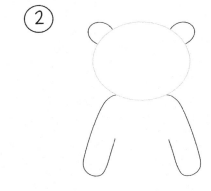

③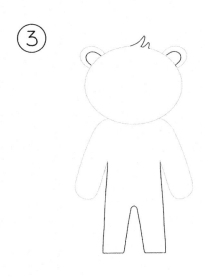

④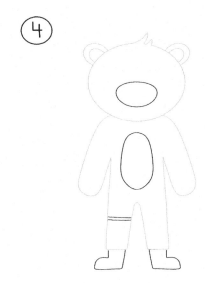

⑤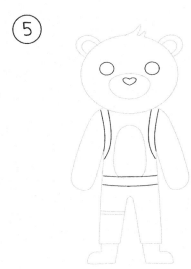

⑥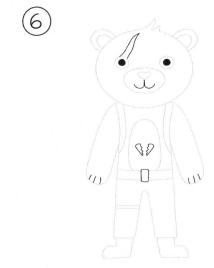

GREAT JOB!

1

2

3

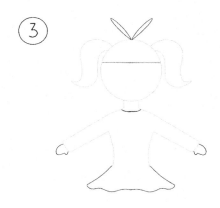

4

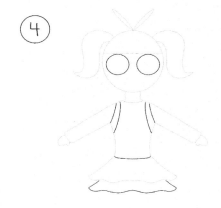

5

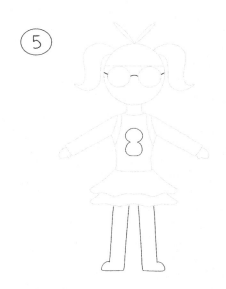

6

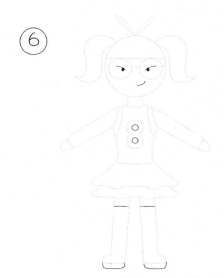

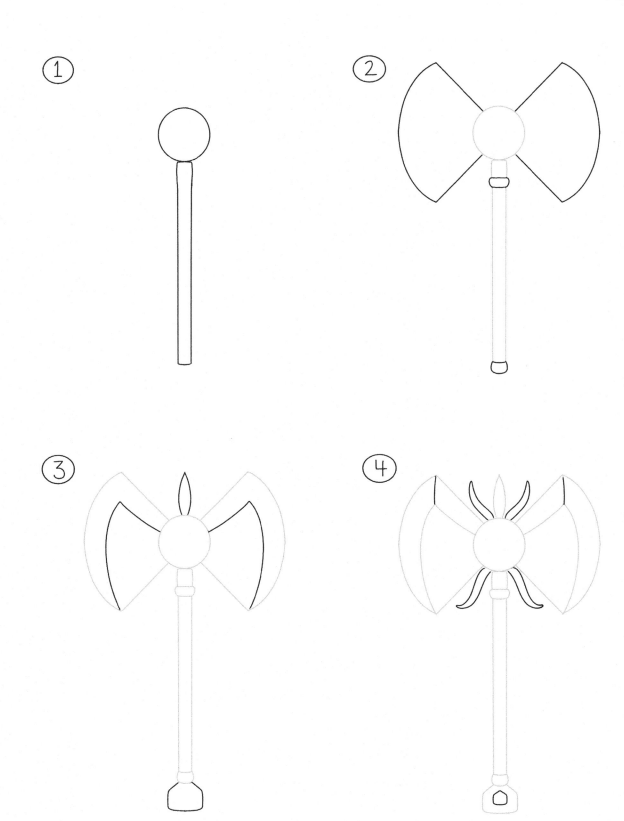

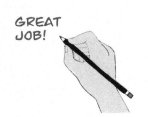

GREAT
JOB!

1

2

3

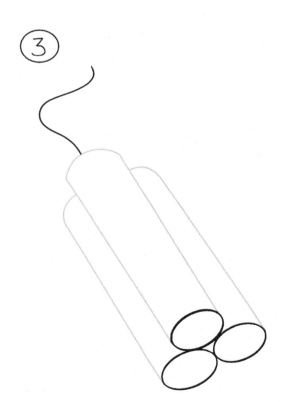

4

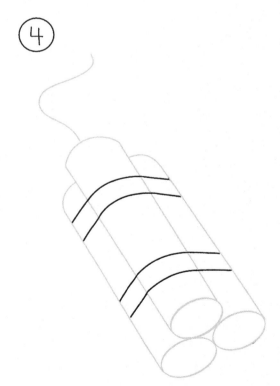

①

②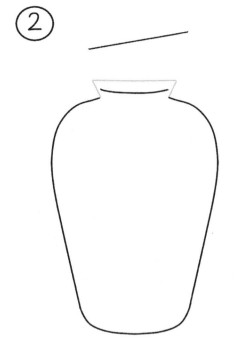

③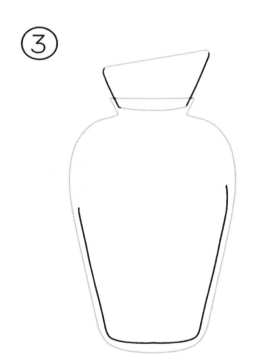

④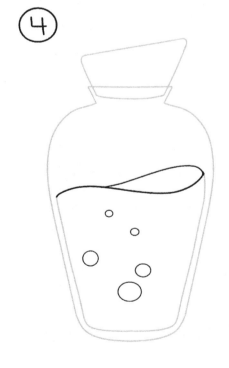

GREAT
JOB!

THIS EXTRA PAGE IS FOR YOU TO DRAW ON!

LET'S
START!

INTERMEDIATE AND HARD

HOW TO DRAW
COD
MINECRAFT

1. Start with a long, narrow rectangular box, as shown.

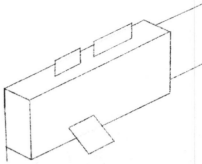

2. Add rectangles to the top and side for fins. Add another at the back for the tail.

3. Make it boxy! Take your time. Follow along with the picture and create a series of squares so that it looks like the fish is made out of boxes. Using a ruler is helpful!

4. Erase some of the boxes and squares to give detail to the front of the fish, to its side fin, and especially the tail. Darken the box where the cod's eye would be.

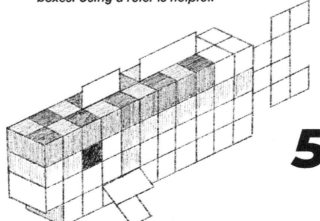

5. Shading is very important for the final look! Looking at the final picture, darken the appropriate squares.

THIS BLANK PAGE IS FOR YOU TO DRAW ON!

GREAT
JOB!

HOW TO DRAW
PIG
MINECRAFT

1. *Start by drawing the outline of the pig: draw a cube and part of a smaller cube at the back.*

2. *Add a rectangular box to the front, which will be the pig's snout. Add tall boxes below for the pig's legs.*

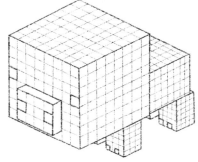

3. *Again, try using a ruler for this part. Draw squares throughout. Pay careful attention to darken certain squares, such as those for the eyes, nostrils, and toes.*

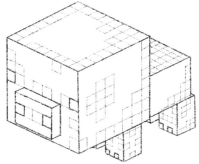

4. *Using an eraser, erase some of the boxes, just like in the picture. This will give some detail to the pig's skin.*

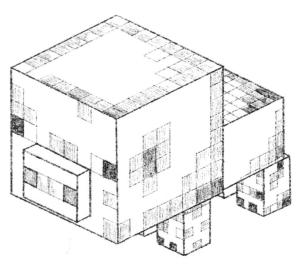

5. *Finally, add shading to the pig, including darkening the eyes, nostrils, and toes. Darken certain squares to give the sketch even more detail.*

THIS BLANK PAGE IS FOR YOU TO DRAW ON!

GREAT JOB!

HOW TO DRAW
PARROT MINECRAFT

1. Start with a rough outline. Draw three shapes, as shown, starting with a large rectangular box for the body and a smaller one for the head. Don't forget the tail!

2. Add another rectangular box to the front of the head, which will be the beak. Draw an angled flat square on the side of the body for a wing.

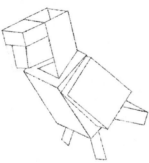

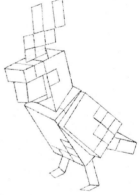

3. Add detail to the beak, separating it into two sections. Also, add more detail to the wings and tail, making them more 3D. Add two shapes for legs.

4. Use more squares for details to the head, including the parrot's eyes and for the crest of feathers on top of the head. Draw the flat feet for the parrot's legs.

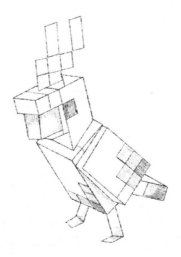

5. Finally, add shading, especially on the beak! Darken the eyes, parts of the body, wing, and tail.

THIS BLANK PAGE IS FOR YOU TO DRAW ON!

GREAT JOB!

HOW TO DRAW
TURTLE
MINECRAFT

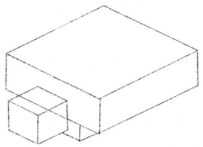

1. Draw a wide, short rectangular box. Draw a cube at the front for the turtle's head. Look closely, there is another shape at the bottom. This is the bottom of the shell.

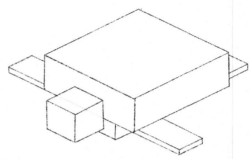

2. Add some flat rectangles for the front limbs. Draw part of a rectangle at the back for the tail.

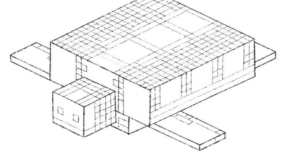

3. Use a ruler! Carefully add small squares for eyes and for detail on the shell. Look at the picture, because there are larger squares running down the center of the shell.

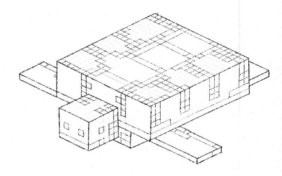

4. Erase some of the small squares you drew to give more detail to the pattern of the turtle's shell.

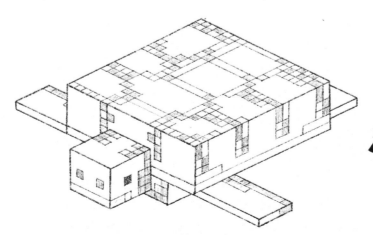

5. Finally, add shading to parts of the turtle's shell. Randomly darken some of the small squares to create a beautiful pattern. Don't forget to darken the eyes!

THIS BLANK PAGE IS FOR YOU
TO DRAW ON!

GREAT
JOB!

HOW TO DRAW
SALMON MINECRAFT

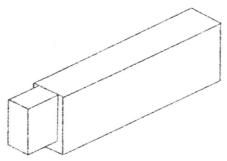

1. Start by drawing one long rectangular box. Draw another smaller one on the front. This will be the salmon's front/head.

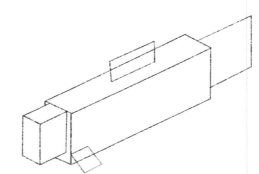

2. Draw flat rectangles for the top fin, side fin, and tail.

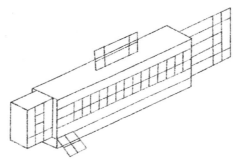

3. Using a ruler, draw small squares down the middle of the salmon's head and along the side of the body. Also, add squares and rectangles, as shown, to the side fins and tail.

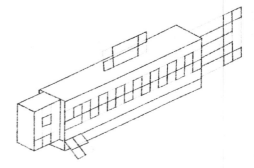

4. Using an eraser, erase some of the small boxes to give the salmon a pattern on the side. Use the eraser to give shape to the eyes, top fin, side fin, and tail.

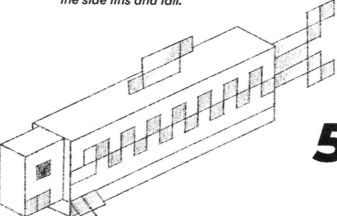

5. Finally, darken the small remaining squares on the side of the salmon. Darken its eyes, and add shading on the fins and tail.

THIS BLANK PAGE IS FOR YOU TO DRAW ON!

GREAT JOB!

HOW TO DRAW
BUTTERFLYFISH
MINECRAFT

1. Start by drawing a rectangular box for the body.

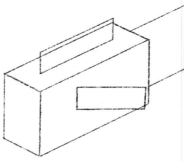

2. Draw long flat rectangles for the top fin, side fin, and tail.

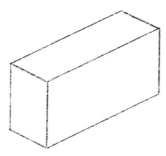

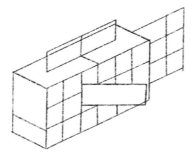

3. Using a ruler, draw small squares on the sides of the body and tail. Also, separate the top fin into two rectangles. Draw a rectangle at the front for the mouth.

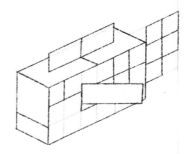

4. Using an eraser, erase some of the small boxes, such as on the fish's underbelly and to give detail to the tail.

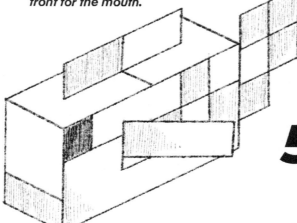

5. Finally, add shading. Darken small boxes, parts of the fins, and darken the eye.

THIS BLANK PAGE IS FOR YOU TO DRAW ON!

GREAT
JOB!

HOW TO DRAW
FOX
MINECRAFT

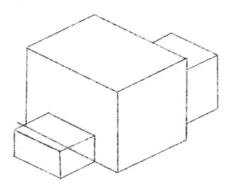

1. Start with a rough sketch of three shapes, including a large rectangular box for the head, a small one at the front for the snout, and a medium one for the body.

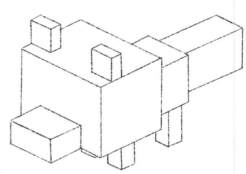

2. Add more small shapes to the top, for ears, and the bottom, for legs. Draw another long rectangular box for the tail.

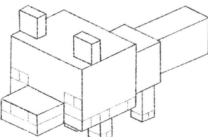

3. Draw small squares for the eyes, nostrils, and feet.

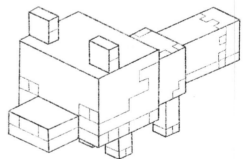

4. Detail each section, including adding lines to the side of the head, body, and tail.

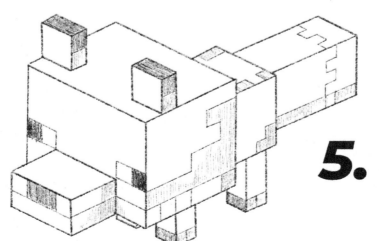

5. Finally, add shading. Darken the sides of the ears and slightly shade some of the squares and shapes, as shown. Darken one box in each eye.

THIS BLANK PAGE IS FOR YOU
TO DRAW ON!

GREAT
JOB!

HOW TO DRAW
BEE MINECRAFT

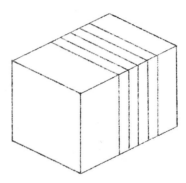

1. Start by drawing a boxy rectangular box for the bee's body.

2. Add lines running over the top and down the side of the body.

3. Draw small squares at the front with open squares hanging off them (like open doors) for the antennae. Using a ruler, add square-filled wings to the top of the bee.

4. Add more detail to the front, including small squares for the eyes and larger shapes for the pattern. Use an eraser to erase some squares to give shape to the wings.

5. Finally, darken the long boxes running on top and the side of the bee to give it its stripes. Darken the shapes, as shown, to detail the pattern.

THIS BLANK PAGE IS FOR YOU
TO DRAW ON!

GREAT
JOB!

HOW TO DRAW
DOLPHIN
MINECRAFT

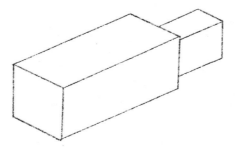

1. *Start with a long rectangular box and draw a smaller one behind it.*

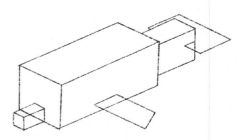

2. *Draw a small rectangular box at the front for the dolphin's snout. Add flat shapes for the side fins and tail.*

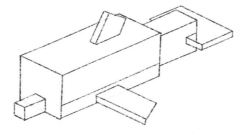

3. *Add detail to the side fins, top fin, and tail. Don't forget to draw a straight line across the side of the body.*

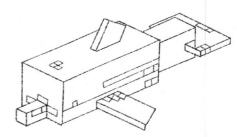

4. *Carefully add small squares and rectangles on the dolphin's face, body, fins, and tail. The details on the snout are important.*

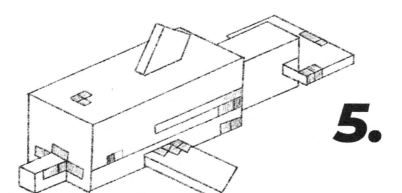

5. *Darken some of the small boxes to add more detail to some parts of the dolphin.*

THIS BLANK PAGE IS FOR YOU
TO DRAW ON!

GREAT
JOB!

HOW *TO* DRAW
VILLAGER MINECRAFT

1. *Start by drawing a rough outline of the villager's body. It should start with three, vertical rectangular boxes. The center one should be more narrow.*

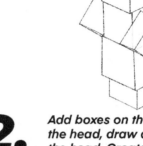

2. *Add boxes on the side for arms. On the head, draw a line going around the head. Create legs by narrowing the bottom box using an eraser and drawing the smaller box.*

3. *Add a small vertical box for the nose. Connect the arms and erase guidelines. Add details to the clothing, including the zigzag pattern on the villager's headdress.*

4. *Detail each section of clothing, including on the head. Add zig zag patterns to the arms and lines on the body and legs.. Don't forget to add two dark dots for eyes!*

5. *Finally, add shading to the villager's clothing, including his head, arms, body, and legs. This helps show the pattern on the clothes.*

THIS BLANK PAGE IS FOR YOU TO DRAW ON!

GREAT
JOB!

HOW TO DRAW
LLAMA
MINECRAFT

1. Start by drawing a large rectangular box for the body. Carefully draw a vertical box attached to the front.

2. Add details by drawing more boxes on the head for the llama's nose and ears. Draw a square on the side of the body to outline the llama's pack.

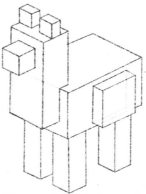

3. Add more detail to the pack to make it 3D. Draw four tall boxes below the body to form four legs. Remember to erase your initial guidelines!

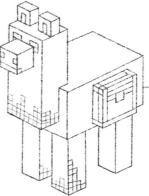

4. Finish detailing each section, including the pack. Draw small boxes on the front of the llama and legs to detail patterns in the fur. Add eyes, nostrils, a mouth and ear holes.

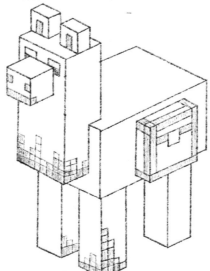

5. Add some shading to the small boxes and on the pack. Darken the eyes, nostrils, mouth, and hear holes.

THIS BLANK PAGE IS FOR YOU TO DRAW ON!

GREAT
JOB!

HOW TO DRAW
CHICKEN MINECRAFT

1. Draw a tall, vertical rectangular box. Draw part of another box at the back for the chicken's body.

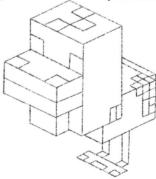

2. Add another box on the front for the chicken's beak. Look carefully, add another box below the beak! Erase your guidelines to clean up the sketch.

3. Draw long skinny rectangles to form the chicken's legs. Connect them at the feet with another rectangle.

4. Draw eyes. Carefully detail each section, adding small squares and rectangles to the head, beak, body, and legs.

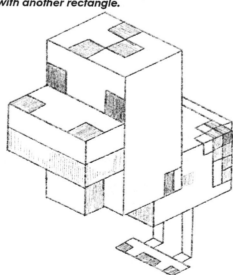

5. Darken the eyes and add shading to certain squares on the chicken, just like the picture!

THIS BLANK PAGE IS FOR YOU
TO DRAW ON!

GREAT
JOB!

HOW TO DRAW
HORSE MINECRAFT

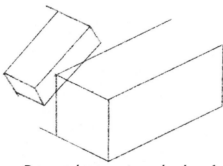

1. *Draw a long rectangular box for the horse's body. Slightly above the body, draw another smaller box for the horse's head.*

2. *Connect the horse's head to the body. Narrow the front of the horse's head to make it look like a mouth and nose, erasing your initial guidelines.*

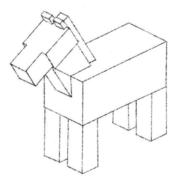

3. *Add details to the horse's head, including lines for the neck and more shapes for the little ears and the mane. Draw rectangular boxes for legs.*

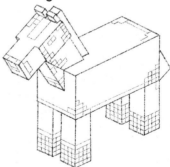

4. *Using a ruler, and using the picture to guide you, draw little squares to give detail to the head and to create hooves on each leg. Draw a mouth and tail.*

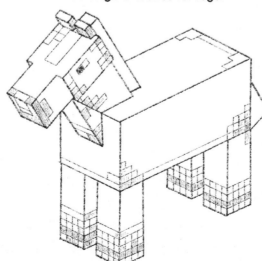

5. *Shading is key here! Darken the eyes, of course, but don't forget to apply shading to the horse's hooves and on its mouth and nose.*

THIS BLANK PAGE IS FOR YOU TO DRAW ON!

GREAT
JOB!

HOW TO DRAW
OCELOT
MINECRAFT

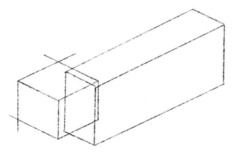

1. Draw a long, narrow rectangular box for the ocelot's body. For its head, draw a simple cube.

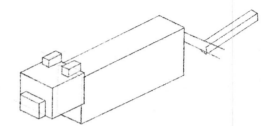

2. Add little boxes for ears and the ocelot's nose and mouth. Create the ocelot's tail by drawing thin, long boxes.

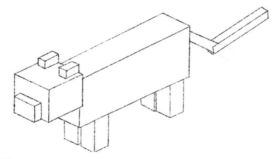

3. Add four short boxes for the ocelot's legs.

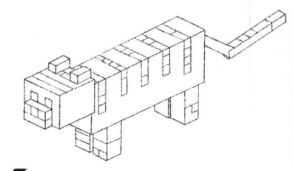

4. Use small squares and rectangles to add details, like stripes on the ocelot's head and body. Also, make sure to draw eyes and detail its mouth and nose.

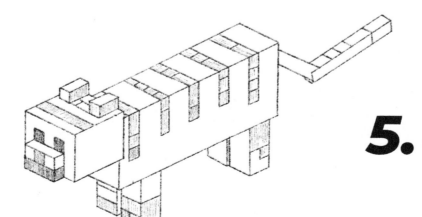

5. Shading is key here! Darken the eyes, of course, but don't forget to apply shading to the horse's hooves and on its mouth and nose.

THIS BLANK PAGE IS FOR YOU TO DRAW ON!

GREAT JOB!

HOW TO DRAW
PUFFERFISH MINECRAFT

1. *Draw a cube.*

2. *Draw little flaps on the edges of the cube. Draw a line going down the center and add two flaps there, as shown.*

3. *Draw small squares in each of the flaps. Also, add squares on the sides of the cube, which will be tiny fins.*

4. *Draw more boxes, including to create the eyes and mouth. Using an eraser, carefully erase some of the small boxes on the edge flaps and on the center flaps.*

5. *Darken a box in each eye and darken the pufferfish's mouth. Darken some of the small boxes on the body and flaps.*

THIS BLANK PAGE IS FOR YOU TO DRAW ON!

GREAT
JOB!

HOW TO DRAW
RABBIT
MINECRAFT

1. Start by drawing a rectangular box for the rabbit's head. Draw part of a box just behind the head for the rabbit's body.

2. Add two tall rectangular boxes on the head, angled inwards, for the ears. Add more boxes to detail the front and back legs.

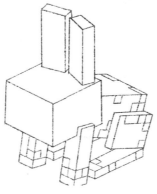

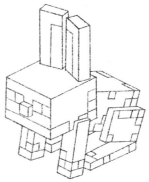

3. Use small boxes to add detail to the rabbit's body and legs.

4. Add more small boxes to the face to create eyes and ear holes. Draw a small, flat box for the rabbit's nose

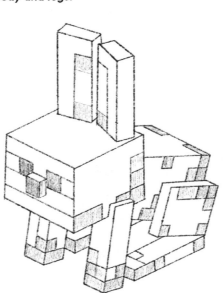

5. Finally, add shading to some of the small boxes for more detail. Don't forget to darken the eyes and nose.

THIS BLANK PAGE IS FOR YOU TO DRAW ON!

GREAT
JOB!

HOW TO DRAW
ALEX
MINECRAFT

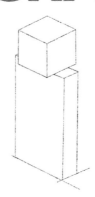

1. First, draw a cube for Alex's head. Draw a long, thin rectangular box for the body.

2. Add two more long boxes, on either side of the body, for arms.

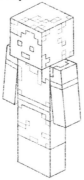

3. Carefully draw straight lines and small boxes to give details to the clothing and head. Draw eyes, a mouth, and Alex's hair (remember to use all straight lines!)

4. Darken the eyes, mouth, and some of the small boxes in Alex's hair. Darken the cuffs of her sleeves and bottom of her shirt.

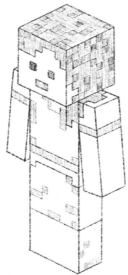

5. Finally, add some lighter shading to Alex's hair without covering up the details of the small squares.

THIS BLANK PAGE IS FOR YOU TO DRAW ON!

GREAT
JOB!

HOW to DRAW
STEVE
MINECRAFT

1. First, draw a cube for Steve's head. Draw a tall, thin rectangular box for the body.

2. Add two more long boxes, on either side of the body, to outline Steve's arms.

3. Using an eraser, shorten the arms to the proper length. Erase your initial guidelines to clean up the picture.

4. Carefully draw straight lines and small boxes to give details to the clothing and head. Draw eyes, a mouth, and Steve's hair. Add lines for clothing and feet.

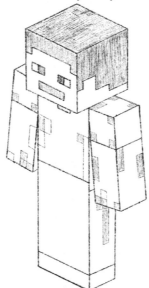

5. Finally, darken Steve's eyeballs, hair, and some of the smaller squares on his clothes and arms.

THIS BLANK PAGE IS FOR YOU TO DRAW ON!

GREAT
JOB!

HOW TO DRAW
POLAR BEAR
MINECRAFT

1. Start by drawing three boxes, increasing in size. The smallest box will be the polar bear's head.

2. Add shapes for the legs and erase some of the initial guidelines to keep the sketch clean.

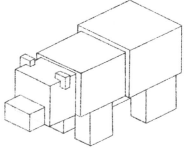

3. Add another box to the head to create the mouth and nose. Draw little L-shapes on top of the head for the ears.

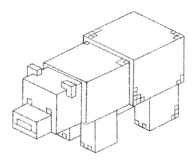

4. Draw the eyes, nose, and a line for the mouth. Draw tiny squares for the claws and for some detail on the body.

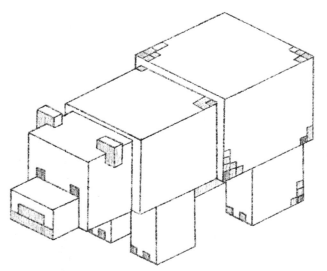

5. Darken the eyes, nose, mouth, and front of the ears. You should also shade the claws and some of the smaller squares on the body.

THIS BLANK PAGE IS FOR YOU TO DRAW ON!

GREAT
JOB!

HOW TO DRAW
WOLF
MINECRAFT

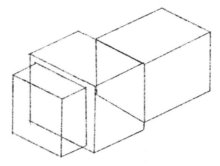

1. *Start by drawing three rectangular boxes. The smallest one, at the front, will be the wolf's head.*

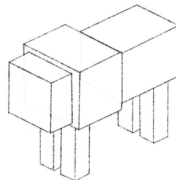

2. *Add four more long, vertical rectangular shapes for the wolf's legs. Erase your guidelines.*

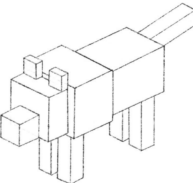

3. *Add small, flat boxes for ears. Draw a cube at the very front for the wolf's mouth and nose. Also, add a long thin box for the tail!*

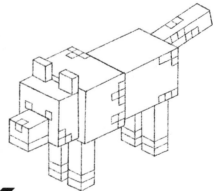

4. *Draw small boxes and rectangles to detail the face and parts of the body. Make sure to add lines at the bottom of the wolf's legs to detail its paws.*

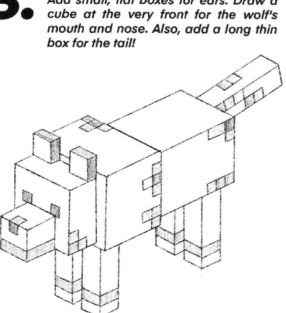

5. *Finally, add shading. Darken the eyes, nose, mouth, and the details on the body. Don't forget to shade the rectangles on the legs.*

THIS BLANK PAGE IS FOR YOU TO DRAW ON!

GREAT
JOB!

HOW TO DRAW
RAILGUN

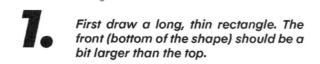

1. *First draw a long, thin rectangle. The front (bottom of the shape) should be a bit larger than the top.*

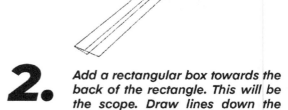

2. *Add a rectangular box towards the back of the rectangle. This will be the scope. Draw lines down the middle of the rail gun, as shown.*

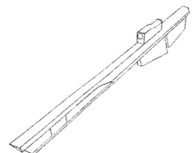

3. *Refine the shape of the scope mount and add a circle. Also, add two shapes at the back end, an outline for the trigger area. At the front, add details to the barrel.*

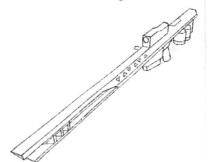

4. *Add more details to the barrel, especially at the front end and the triangles on the side. At the back, carefully draw railgun canisters, the trigger handle, and magazine.*

5. *Finish by adding shading to the body of the gun, including darkening the triangles and the area visible in the barrel.*

THIS BLANK PAGE IS FOR YOU TO DRAW ON!

YOU
ROCK!

HOW TO DRAW
ROCKET LAUNCHER

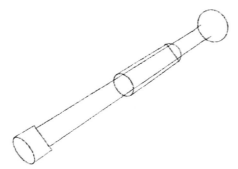

1. Start with a rough sketch of the rocket launcher, using appropriately sized cylinders and circles, as shown.

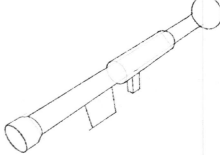

2. Add details to the body, including an outline for the trigger, grip, and handle. Start refining the shape of the barrel, including the muzzle end of the barrel.

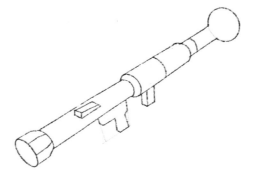

3. Add more details, including shaping the trigger grip. Add more details to the barrel, including adding rounded lines along the tube. Erase guidelines not being used!

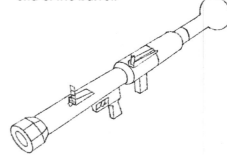

4. Finish detailing each section of the rocket, including adding a trigger, sights, and shape to the muzzle launcher.

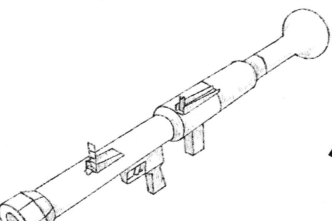

5. Finally, add shading to the launcher, including on the handle, grip, and along the bottom of the barrel.

THIS BLANK PAGE IS FOR YOU
TO DRAW ON!

YOU
ROCK!

HOW TO DRAW
GRENADE LAUNCHER

1. *Start by drawing a long cylinder. Draw a large circle around the center and a smaller one at the back. Connect these two circles. This will be the revolving cylinder.*

2. *Add details to the grenade launcher, including the shapes below the barrel and on top of the revolving cylinder.*

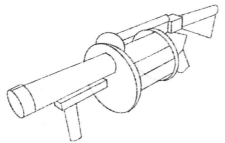

3. *Draw a handle under the barrel. Draw the back buttstock, back grip, and more details to the rotating cylinder. Remember to erase your rough sketch guidelines!*

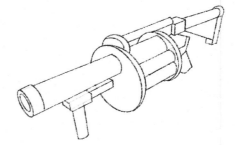

4. *Detail each section of the launcher, including the end of the muzzle, the individual cylinders in the revolving section, and details to the stock and grip.*

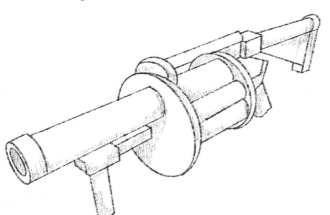

5. *Finish by adding shading to the grenade launcher.*

THIS BLANK PAGE IS FOR YOU
TO DRAW ON!

YOU
ROCK!

HOW TO DRAW
SHOTGUN

1. *Start by making a long, thin rectangular box with a little cylinder at the end. Draw a line down the center of the box.*

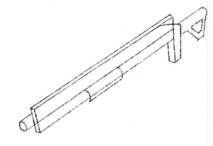

2. *Add a grip and buttstock at the back of the shotgun and draw a foregrip at the center. Round out the top of the shotgun towards the back.*

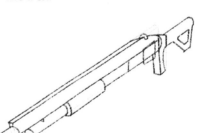

3. *Fill in small details, such as refining the foregrip, slide, and trigger grip area.*

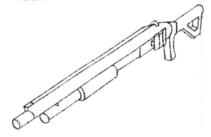

4. *Finish adding details to each section, including adding extra shells on the side of the shotgun.*

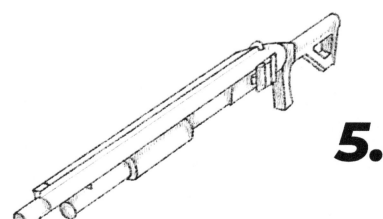

5. *Finish by adding shading to the shotgun, including at the back end and in the barrel.*

THIS BLANK PAGE IS FOR YOU
TO DRAW ON!

YOU
ROCK!

HOW TO DRAW
SUBMACHINE GUN

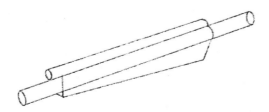

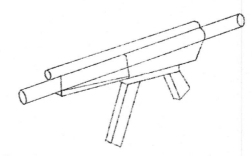

1.

Start your sketch by drawing a long, thin cylinder. Draw another, shorter cylinder on top. Finally, draw a narrow, long triangle at the bottom.

2.

Add outlines for the grip and magazine.

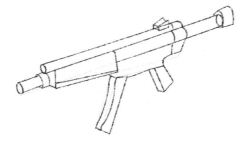

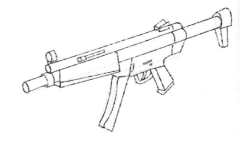

3.

Begin adding details, such as the iron sights. Curve the lines of the magazine, narrow the barrel, and draw the outline for the buttstock. Erase initial guidelines.

4.

Finish adding details to each section, including the front sight, the stock, the trigger, and other details to the magazine and side of the handguard.

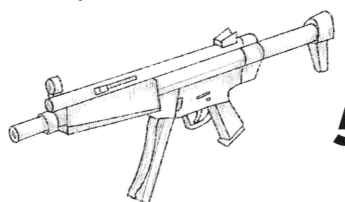

5.

Finish by adding shading each of the sections of the submachine gun.

THIS BLANK PAGE IS FOR YOU
TO DRAW ON!

YOU
ROCK!

HOW TO DRAW
SNIPER RIFFLE

1. *Start by drawing a very long, thin cylinder. Draw the outline for the body of the sniper rifle.*

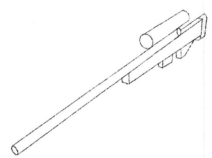

2. *Add a large, short cylinder for the scope. Add details to the grip area, including the magazine and butt of the sniper rifle.*

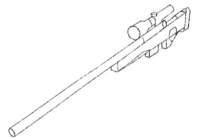

3. *Add details to the scope, narrowing the middle of it. Also add details to the grip, including the outline of the trigger.*

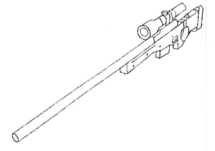

4. *Finalize each section, including adding details to the scope, trigger area, and magazine. Draw small dots on the side of the armguard.*

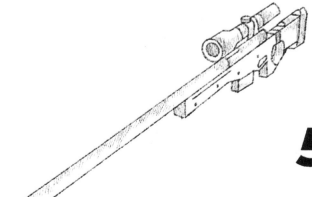

5. *Finally, finish your drawing by adding shading to the barrel and in areas at the back.*

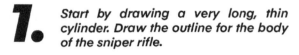

THIS BLANK PAGE IS FOR YOU TO DRAW ON!

YOU ROCK!

HOW *TO* DRAW
CROSSBOW

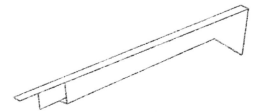

1. *Start by drawing a light, rough sketch of the body of the crossbow and back handle.*

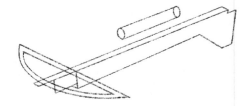

2. *Draw the bow shaped "limb" at the front and draw a cylinder for the scope.*

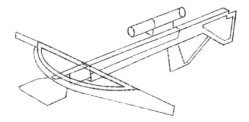

3. *Add details to the limb and scope. Also, add details to the side of the central body and at the back end, to the trigger grip and stock. At the front end, draw the stirrup.*

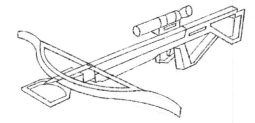

4. *Detail each section of the crossbow, including refining the scope, stock, trigger grip and stirrup. Don't forget to draw a trigger.*

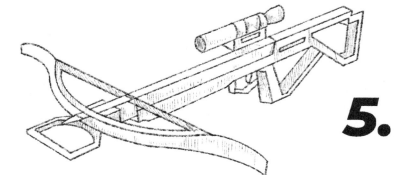

5. *Finish your sketch by carefully adding shading to the crossbow. Vertical lines for shading help give the limb a realistic look.*

THIS BLANK PAGE IS FOR YOU TO DRAW ON!

YOU ROCK!

HOW TO DRAW
PISTOL

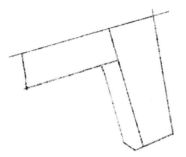

1. *Start by making a rough shape of the shape of the pistol.*

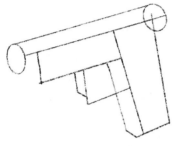

2. *Add details to the pistol, including the front barrel, side of the barrel, grip, and trigger guard.*

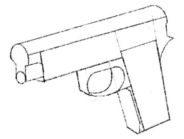

3. *Continue adding details to refine the shape of the pistol, including the muzzle and trigger guard. Erase guidelines to keep the sketch looking clean.*

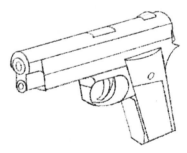

4. *Finalize details to each section of the pistol, including adding the trigger, chamber port on top of the slide, and details as shown.*

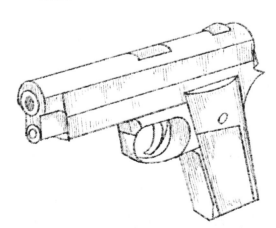

5. *Finish by adding shading to the gun to give it a realistic look.*

THIS BLANK PAGE IS FOR YOU TO DRAW ON!

YOU
ROCK!

HOW TO DRAW
PIRATE
ROBLOX

1. It starts simple enough. Draw the shapes as shown for an outline of the Roblox Pirate.

2. Add the outline of the pirate hat on top of the head. Draw lines to separate arms and the one foot. Add a line on the head for an outline of the hair.

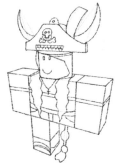

3. Draw a thin peg leg for the pirate. Add ornamental details to the hat and a line on the front for the shirt.

4. Slowly add details to each section, including the skull and bones on the hat. Draw the face. On the body, draw the pirate's long hair. Add details to the clothing.

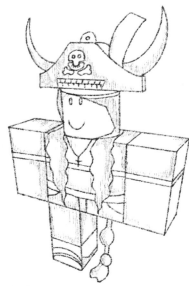

5. Darken the hair and add shading throughout the Pirate.

THIS BLANK PAGE IS FOR YOU TO DRAW ON!

YOU
ROCK!

HOW TO DRAW
PUNK ROBLOX

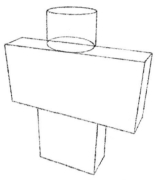

1. Start with the three shapes shown for an outline of the Roblox Punk

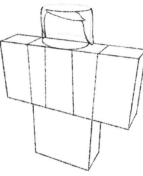

2. Add details to the head, outlining the hair. Draw lines on the torso for more details to clothing.

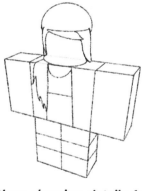

3. Continue drawing details for the hair, including long hair going down the front of the torso.

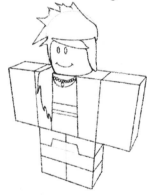

4. Carefully draw the Punk's spiky hair. Draw the face, and more details to the clothing. Don't forget the beaded necklace!

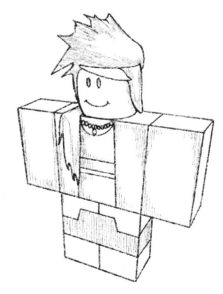

5. Finish your sketch by shading the hair and parts of the clothing. You can darken the necklace too.

THIS BLANK PAGE IS FOR YOU TO DRAW ON!

YOU
ROCK!

HOW TO DRAW
BULL
ROBLOX

1. *Draw a short cylinder for the Roblox Bull's head and a thin rectangular box for the body.*

2. *Add lines on the side for arms. Begin drawing the legs.*

3. *Add horns and begin drawing an outline for the head. Add details to the torso clothing. Pay attention to the details added to the legs!*

4. *Draw Bull's upset face and add details to the hair. Make sure to erase guidelines to keep the sketch clean.*

5. *Finish by adding shading to the hair, horns, mouth, and around the body and legs.*

THIS BLANK PAGE IS FOR YOU TO DRAW ON!

YOU
ROCK!

HOW TO DRAW
MAGICIAN ROBLOX

1. *Carefully draw the cylinder, rectangular box, and circles and squares for a rough, initial outline of the Roblox Magician.*

2. *Slim down the body by erasing your initial guidelines and curving the new lines in. Begin adding detail to the arms and clothing.*

3. *Draw the brim of the Magician's hat! Add more details, including the shoes and an outline for the Magician's hands.*

4. *Finalize details for each section: draw the face, draw his tie, collar, vest and buttons. Add finger lines and more detail to the clothing.*

5. *Finish by adding shading to your newly drawn Magician!*

THIS BLANK PAGE IS FOR YOU TO DRAW ON!

YOU ROCK!

HOW TO DRAW
MINEGIRL ROBLOX

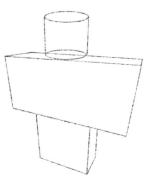

1. Start with the three shapes shown for an outline of the Roblox Minegirl.

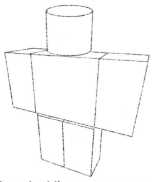

2. Add vertical lines to separate arms and legs.

3. Add details to the clothing, including an outline for the overalls and lines for the shoes.

4. Section by section, slowly add details for the Minegirl: draw the face, draw the T-Shirt design under the overalls, and the other details on the overalls.

5. Finish by adding shading to Minegirl.

THIS BLANK PAGE IS FOR YOU TO DRAW ON!

YOU
ROCK!

HOW TO DRAW
LOLERIS ROBLOX

1.
Start by drawing a large, thin rectangular box. Draw another box below that box, a bit to the left of center. Draw yet another box for the arm, and draw the cup-shaped head.

2.
Add an outline of a sword in Roblox Loleris' hand. Add lines to make the other arm and legs. Start outlining the hair.

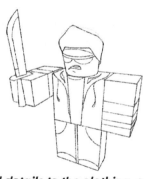

3.
Start adding detail to the clothing and sharpen the shape of the blade. Make sure to add a handle to the blade. Draw the rim of sunglasses along the head.

4.
Add details to the clothing, creating a sweatshirt look. Draw sunglasses, an angry face, and make sure to shape the hair as shown.

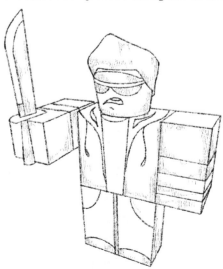

5.
Finish Loleris by adding shading in different areas throughout.

THIS BLANK PAGE IS FOR YOU TO DRAW ON!

YOU
ROCK!

HOW TO DRAW
ANGRY MAN ROBLOX

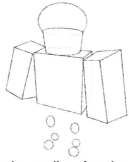

1. *Start by drawing a large, thin rectangular box. Draw a wide, bowl-shaped head. On each side, draw angled rectangular boxes for the arms.*

2. *Draw the outline for the Roblox Angry Man's hair. Draw circles to begin the outline for his legs.*

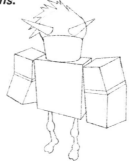

3. *Draw horns and the spiky outline of the hair. Add details to the clothing and begin connecting the legs.*

4. *Draw the angry face and add a headband. Finish adding details to the clothes and refining the legs.*

5. *Add shading to the character, including darkening his open, angry mouth.*

THIS BLANK PAGE IS FOR YOU
TO DRAW ON!

YOU
ROCK!

HOW TO DRAW
GREEN CAT
ROBLOX

1. Start with the three shapes shown for an outline of the Roblox Green Cat.

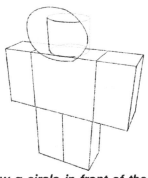

2. Draw a circle in front of the head. This will be the front of the hood. Add lines for legs and arms.

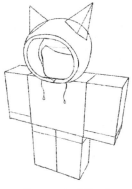

3. Draw the rest of the hood going around the head. Draw triangles on top of the hood to outline the cat ears. Draw a couple of threads for the sweatshirt's pull strings.

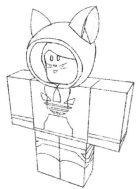

4. Draw the face, including little whiskers. Add details to the clothing, including the logo and the details on the shorts. Make sure to shape the ears!

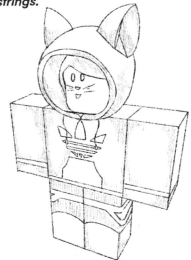

5. Add shading throughout the Green Cat, including in the big ears.

THIS BLANK PAGE IS FOR YOU TO DRAW ON!

YOU
ROCK!

HOW TO DRAW
MAFIA ROBLOX

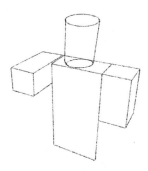

1. Draw a vertical cylinder for the head. Draw three rectangular boxes for the body and arms.

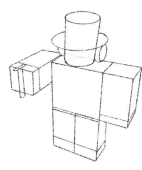

2. Add details to the Roblox Mafia, including the brim of the hat, clothing details, and the handle of the weapon.

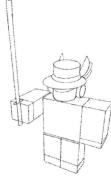

3. Add ornamental details to the mafia hat and draw an outline of a long sword.

4. Finish details in each section, including drawing his suit and tie and completing the mafia hat. Add grooves to the sword hilt and don't forget the mouth!

5. Add shading to the sword and to the suited mafia man.

THIS BLANK PAGE IS FOR YOU
TO DRAW ON!

YOU
ROCK!

HOW TO DRAW
QUINCY
ROBLOX

1. *Start with the three shapes shown for an outline of Roblox Quincy.*

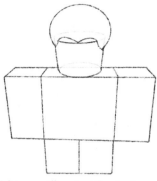

2. *Add an outline for the hair and lines for the legs and arms.*

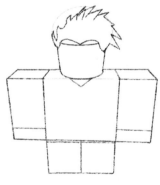

3. *Begin adding details to the hair, drawing spiky parted hair. Add details to the clothing.*

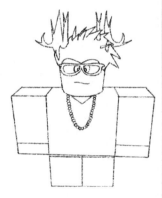

4. *Give it even more detail by adding eyeglasses, cross eyes, and a mouth. Add more spikes to Quincy's hair and draw a necklace.*

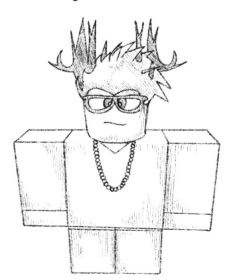

5. *Finish by adding shading to Quincy, including darkening the back hair spikes and the rims of the glasses.*

THIS BLANK PAGE IS FOR YOU
TO DRAW ON!

YOU
ROCK!

HOW TO DRAW JENNI ROBLOX

1. Draw a rough outline for Roblox Jenni, using the rectangular boxes shown. Draw a wide bowl-shaped outline for her head.

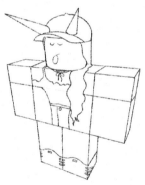

2. Add details to the clothing, an outline for her hair, and two long cones for horns.

3. Draw the brim of a baseball hat. Carefully draw Jenni's hair on her head and go down her front.

4. Draw Jenni's face and add details to the clothing.

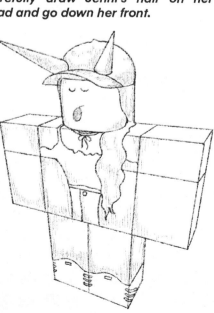

5. Complete your Jenni sketch by adding shading to the hat, horns, and to Jenni herself.

THIS BLANK PAGE IS FOR YOU TO DRAW ON!

YOU ROCK!

HOW TO DRAW
BEAST
ROBLOX

1. *Start by drawing a thin rectangular box for the body. Draw angled rectangular boxes for the arms. Do the same for legs. Draw a bowl-shaped head.*

2. *Look closely at how Roblox Beast's arms and legs bend in the sketch. Do the same, and erase initial guidelines. Draw an outline for the hair.*

3. *Add clothing details to the arms and legs.*

4. *Carefully finish detailing Beast, including the spiky hair, bandana, the snake on the arm, and gas mask on the front, and the face with the spiky teeth!*

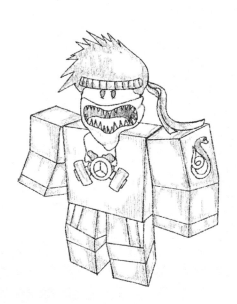

5. *Finish the Beast by adding shading to the clothing, snake, and gas mask. Darken the back of the angry open mouth and add shading to the hair.*

THIS BLANK PAGE IS FOR YOU TO DRAW ON!

YOU
ROCK!

HOW TO DRAW
ASSAULT RIFLE

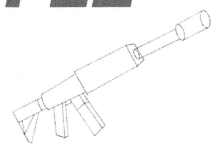

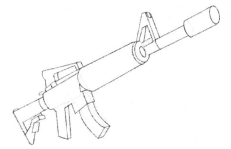

1. *Start by making a light sketch of the rifle's shape using a box for the handguard (large center piece) and appropriately-sized cylinders for the barrel and muzzle break.*

2. *Refine the sketch, rounding the handguard's box, curving the magazine, and adding a triangular outline for the front sight.*

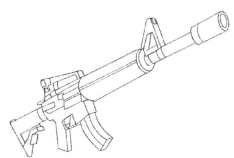

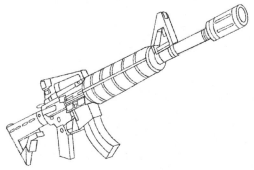

3. *Fill in smaller details like the magazine release and line to represent the long grooves down the middle of the handguard and magazine.*

4. *Detail the rifle section by section, from the notches in the buttstock to the texture across the handguard, and the openings in the muzzle break. Be sure to erase the guidelines as you go to clean up the sketch.*

5. *Finish by adding shading to create a more realistic look.*

THIS BLANK PAGE IS FOR YOU
TO DRAW ON!

LET'S
START!

HOW *TO* DRAW
BURST ASSAULT RIFLE

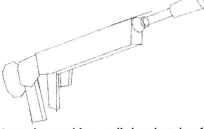

1. *Start by making a light sketch of the rifle's shape using an angled box for the handguard and appropriately-sized cylinders for the barrel and muzzle break.*

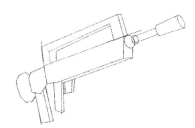

2. *Add a triangular outline for the carry handle rear sight on top of the rifle.*

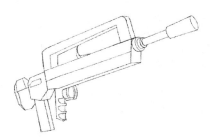

3. *Fill in smaller details like the trigger and the finger impressions for the grip.*

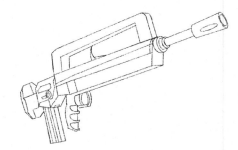

4. *Detail the rifle section by section, from the shaping of the buttstock to the openings in the muzzle break. Be sure to erase the guidelines as you go to clean up the sketch.*

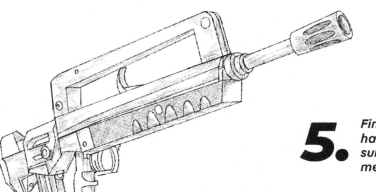

5. *Finish by adding shape to the handguard and shading across the surface to create the illusion of solid metal.*

THIS BLANK PAGE IS FOR YOU TO DRAW ON!

LET'S START!

HOW TO DRAW
BURST FIRE ASSAULT RIFLE

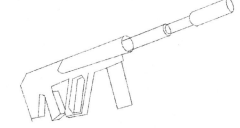

1. Start by making a light sketch of the rifle's shape using a large cylinder for the handguard and appropriately-sized cylinders for the barrel and muzzle break.

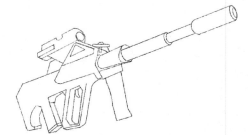

2. Add a triangular outline for the carry handle rear sight on top of the rifle.

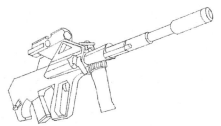

3. Fill in smaller details like the trigger and the finger impressions for the grip.

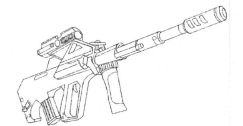

4. Detail the rifle section by section, from the shaping of the buttstock to the openings in the muzzle break. Be sure to erase the guidelines as you go to clean up the sketch.

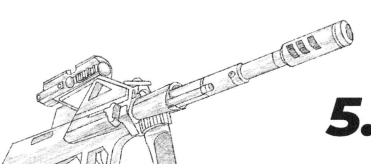

5. Finish by adding shape to the handguard and shading across the surface to create the illusion of solid metal.

THIS BLANK PAGE IS FOR YOU
TO DRAW ON!

LET'S
START!

HOW TO DRAW
IRON MAN GUN

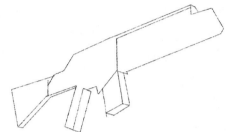

1. Start by making a light sketch of the Iron Man Gun's shape, including the trapezoid shaped front section barrel.

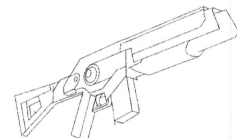

2. Add details to the gun, including to the buttstock, trigger, and the futuristic details on the side of the gun and on the front section.

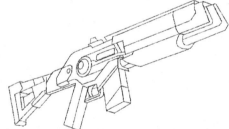

3. Continue by adding lines to create sections on the buttstock, magazine, and front section. Add a small sight on top of the gun.

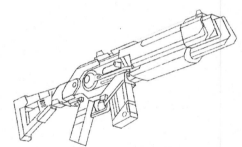

4. Detail the gun section by section, as shown, including drawing lines to accent the trigger guard, magazine, and front section. Don't forget to add the front sight.

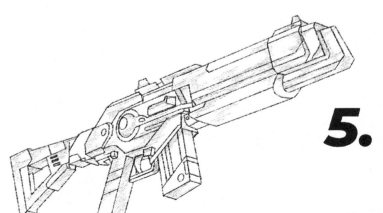

5. Finish by adding shading to the sections and smaller details.

THIS BLANK PAGE IS FOR YOU TO DRAW ON!

LET'S START!

HOW TO DRAW
PUMP
SHOTGUN

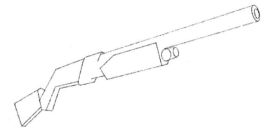

1. *Start by making a light sketch of the pump shotgun, including the rectangular forestock (pump) and a long cylinder for the barrel.*

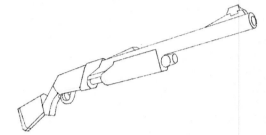

2. *Add the trigger, trigger guard, and sights on top of the chamber and barrel. Make sure to detail the part of the chamber where the forestock slides back to reload.*

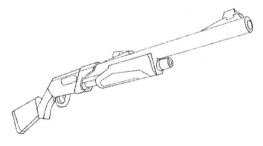

3. *Fill in small details, including the loading port for shotgun shells and the accents on the forestock and magazine cap (circular part in front of the forestock).*

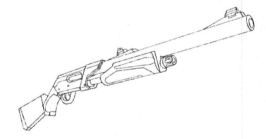

4. *Finish detailing each section, including the loading port, chamber, and adding further detail to the forestock, magazine cap, and sights.*

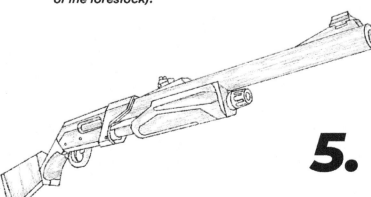

5. *Finish by adding shading to all sections from the buttstock to the barrel.*

THIS BLANK PAGE IS FOR YOU
TO DRAW ON!

LET'S
START!

HOW TO DRAW
PISTOL

1. *Start by making a light sketch of the pistol, including a long straight barrel and slide, grip, trigger, and trigger guard.*

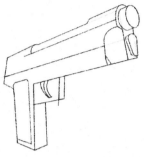

2. *Add details to the barrel, including raising the front end and adding a short cylinder for the muzzle. Also draw a rectangular shape for the grip.*

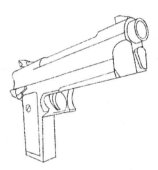

3. *Draw triangular sights on top of the pistol and add more details on the slide and front of the pistol. Refine the shape of the trigger guard, curving the front of it.*

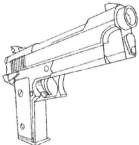

4. *Detail each section, adding screws to the grip, parallel lines to the back of the slide, and further detail to the muzzle area.*

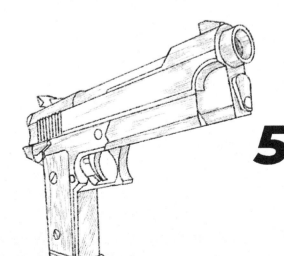

5. *Finish by adding shading to the gun to give it a realistic, metal look.*

THIS BLANK PAGE IS FOR YOU TO DRAW ON!

LET'S START!

HOW TO DRAW
TACTICAL SUBMACHINE GUN

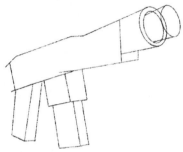

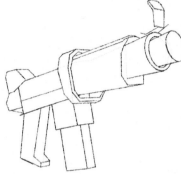

1. *Start with a light sketch. Look closely! Create the muzzle by drawing appropriately sized circles and cylinders. Draw boxes for the grip, magazine catch, and magazine.*

2. *Add details to the grip. Shape it to look sort of like the shape of a leg and foot. Add details to the barrel and handguard, including the octagon at the center.*

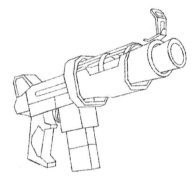

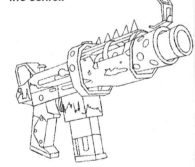

3. *Add more details, such as to the front sight. Continue perfecting the handguard, making it look like it's encasing the barrel. Don't forget the trigger!*

4. *Continue detailing each section. This gun is very unique, with peeling metal and jagged sharp triangles on top of the handguard. Add holes to the muzzle.*

5. *Finish by adding shading to the gun, including darkening the holes of the muzzle and darkening areas of peeling metal.*

THIS BLANK PAGE IS FOR YOU TO DRAW ON!

LET'S START!

HOW TO DRAW
ROCKET LAUNCHER

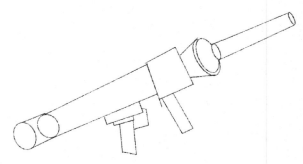

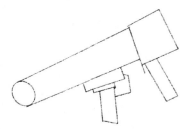

1. Start by making a light sketch of the back of the launcher. Draw a cylinder with a flat front end. Draw boxes for outlining the center and grips. Draw the trigger guard.

2. Continue drawing the rough shape of the rocket launcher, including the back cylinder section (the breech), front muzzle, and outlining the rocket grenade.

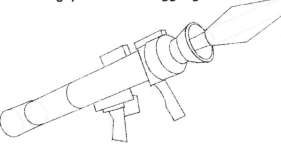

3. Continue by adding detail to the center assembly and refining the shape of the front grip. Draw a diamond shaped rocket grenade with a circular tip. Add sights.

4. Detail each section, including small changes to the center assembly, muzzle, breach, and trigger guard. Add outlines of eyes and a mouth on the rocket.

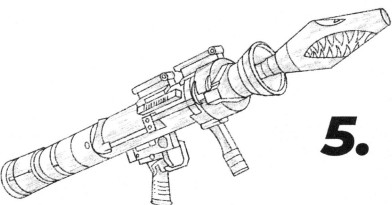

5. Add lines to the back grip and foregrip, breech, and throughout the body of the launcher. Add eyeballs and teeth to the rocket. Finally, add shading!

THIS BLANK PAGE IS FOR YOU
TO DRAW ON!

LET'S
START!

HOW TO DRAW
JONESY
FORTNITE

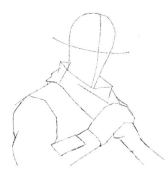

1. Start with a rough shape of Jonesy's body, starting with his collar then on to shoulders, arms, and hands. Draw his head and add horizontal and vertical guidelines.

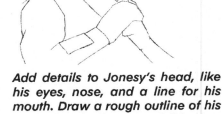

2. Add details to Jonesy's head, like his eyes, nose, and a line for his mouth. Draw a rough outline of his hair and outline his visible ear. Erase your rough guidelines!

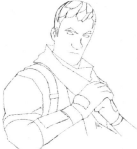

3. Continue adding details to the face, hair, and eyebrows. Round out the nose and add finger lines. Finally, add details to clothing, such as sleeves and straps.

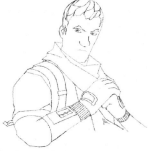

4. Draw pupils in Jonesy's eyes and more detail to his ear. Add more details to his gloves, bracelets, and the tactical screen on his arm.

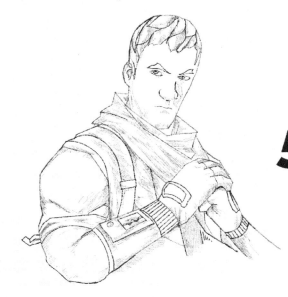

5. Add shading to Jonesy's hair and behind his nose. Add shading to Jonesy's clothing. Take your time!

THIS BLANK PAGE IS FOR YOU TO DRAW ON!

LET'S START!

HOW TO DRAW
HEADHUNTER FORTNITE

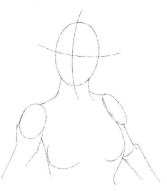

1. *Start with a rough shape of Headhunter's body, including her torso, shoulders, arms and a circular outline for her head.*

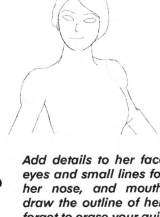

2. *Add details to her face, including eyes and small lines for eyebrows, her nose, and mouth. Carefully draw the outline of her hair. Don't forget to erase your guidelines!*

3. *Add detail to the bangs and outline her hair over her shoulder. Finish drawing her eyebrows. Outline her clothes, including her collar and shoulder strap.*

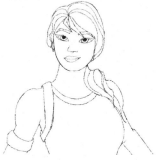

4. *It's all about the hair. Add detail to the hair and create strands. Detail Headhunter's eyeballs. Add details to her nose and draw her lips.*

5. *Finish by adding shading to her hair, one side of her neck, and arms.*

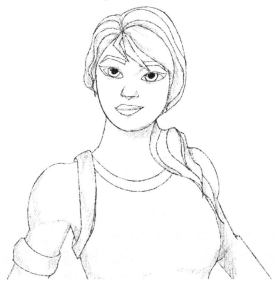

THIS BLANK PAGE IS FOR YOU TO DRAW ON!

 LET'S START!

HOW TO DRAW
WOOD

1. *Start with a simple outline of three long cylinders. This will be your stack of wood!*

2. *Add a slight curve to the cylinders and erase your original guidelines.*

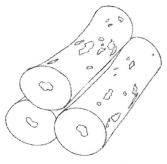

3. *Add details to the wood, including small, jagged shapes at the mouth of each cylinder. Add more jagged shapes throughout the sides so it starts to look like bark.*

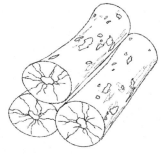

4. *Add more detail! Add cracks at the end of each cylinder. Add more lines between the jagged shapes on the bark.*

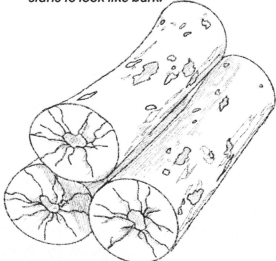

5. *Finally, add shading in the space between the wood and darken the holes and cracks.*

THIS BLANK PAGE IS FOR YOU TO DRAW ON!

 LET'S START!

HOW TO DRAW STONE

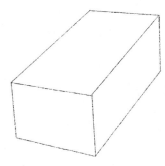

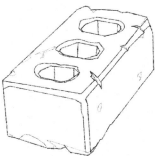

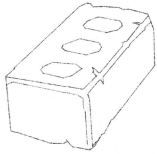

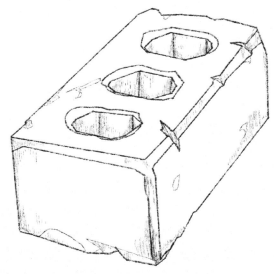

1. Start with a rough sketch of a three dimensional box (called a rectangular prism or rectangular box), using straight lines as the initial guidelines.

2. Make the lines a little more jagged and erase your original guidelines.

3. Add detail to the stone, including drawing parallel jagged lines. Draw three holes on top of the stone (just like bricks in real life).

4. Add details to the holes, drawing vertical lines to give them depth. Add small irregular shapes throughout the stone to make it look chipped in certain places.

5. Finish by adding shading within the holes. Darken the chipped areas.

THIS BLANK PAGE IS FOR YOU TO DRAW ON!

LET'S START!

HOW TO DRAW METAL

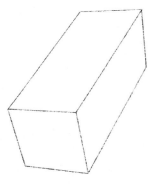

1. Start with a rough sketch of a rectangular box, just as shown.

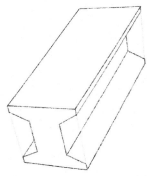

2. Add lines to narrow the front end (sort of like a broad, capital "I"). Add long lines extending out to give the capital "I" some shape. Don't forget to erase your guidelines!

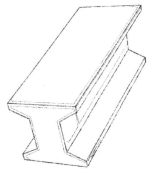

3. Draw parallel lines for everything you've drawn so far, just like in the picture. This gives the metal some more depth.

4. Add details to the metal, like peeled off, scuffed, or chipped areas.

5. Finish shading the side of the metal.

THIS BLANK PAGE IS FOR YOU
TO DRAW ON!

LET'S
START!

HOW TO DRAW
SHIELD POTION

1. Start by making big, wide circular lines for the outline of the glass. Draw the lid using cylinders, and don't forget to outline the latch and ribbon.

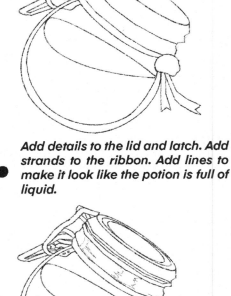

2. Add details to the lid and latch. Add strands to the ribbon. Add lines to make it look like the potion is full of liquid.

3. Add bubbles! Also, carefully add details to the lid and latch.

4. Add texture to the lid by adding some jagged lines on the side of the lid. Add more bubbles. Also, add details to the ribbon.

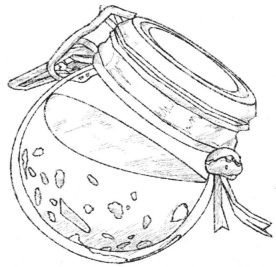

5. Finish by adding shading to the shield potion.

THIS BLANK PAGE IS FOR YOU TO DRAW ON!

 LET'S START!

HOW TO DRAW
BANDAGE

1. Start with two cylinders. For the vertical one standing up, add a rectangle crossing the middle, squeezing the center of the cylinder.

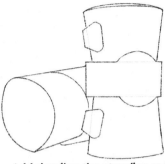

2. Add detail to the standing cylinder, like the circular outline in the middle of the rectangle (like a belt). Add outlines for the grips/latches that hold the bandages in place.

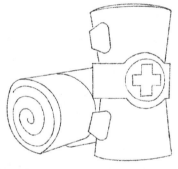

3. Draw a circle at the center of the rectangle/belt shape. Draw a medical cross in the center of that circle. Draw a spiral on the front of the other cylinder.

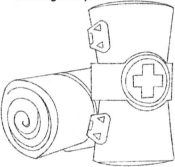

4. Add details to the latches/grips, medical symbol, and spiral on the other bandage.

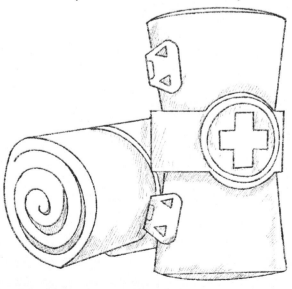

5. Add shading to the spiral. Add shading around the medical symbol/belt and as shown.

THIS BLANK PAGE IS FOR YOU TO DRAW ON!

LET'S START!

HOW TO DRAW
MEDKIT

1. *Start by making a wide rectangular box with straight lines.*

2. *Add curves to the straight lines at each end and erase your guidelines. It should start to look like the top of a chest.*

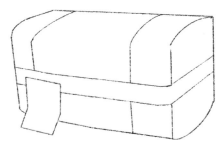

3. *Add details to the body of the medkit and start the outline for the medkit lock.*

4. *Detail each section of the medkit, including adding shape to the medkit lock. Add more details to the middle of the medkit, where it opens. Draw part of a medical cross on top.*

5. *Darken the medical symbol on top and add shading to the medkit to give it a more realistic look.*

THIS BLANK PAGE IS FOR YOU
TO DRAW ON!

LET'S
START!

HOW TO DRAW
GRENADE

1. Start with a light outline of a cylinder. At the top, draw a rectangle for the grenade lid and a long rectangular prism for the lever.

2. Add details to the shape of the cylinder: make it a bit slimmer in the middle. Also, add details to the lever and lid, giving them more angles. Erase your guidelines.

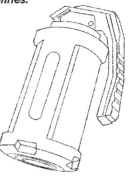

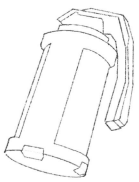

3. Continue adding details to the body of the grenade, including small accents to the bottom. Add more layers to the lever and lid.

4. Finish detailing each section, including a long wide oval on the side. Add grooves to the lever and metallic details to the lid. Finally, add circles and depth to the bottom.

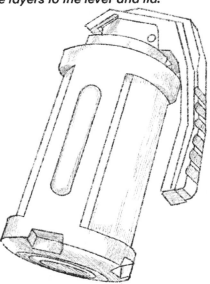

5. Finally, add shading to the grenade, including darkening the bottom and side. Darken the grooves on the side.

THIS BLANK PAGE IS FOR YOU
TO DRAW ON!

LET'S
START!

HOW TO DRAW
ISLANDER PREVALENT

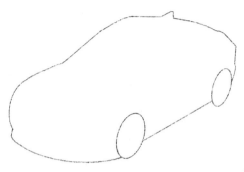

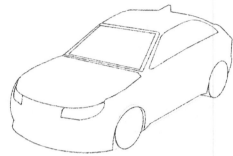

1. Outline the shape of the car, including two circles for the visible wheels.

2. Add the front hood and draw two headlights (they aren't the exact same shape!). Draw the windshield and the outline of the side windows.

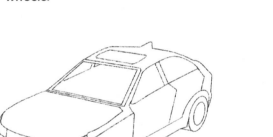

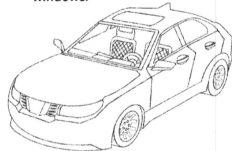

3. Add details to the front bumper. Draw lines for tires, doors, side windows, and a sunroof. Look closely, you can see the other side of the car through the front windshield.

4. Detail each section of the car, including adding rims and detail to the front bumper. Add door handles and detail the interior of the car, including seats and steering wheel.

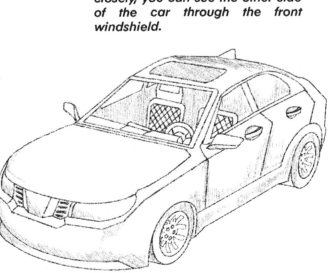

5. Shading makes a huge difference! Add shading to the car, including the interior. Darken the sunroof and add shading to the body to make it more realistic.

THIS BLANK PAGE IS FOR YOU TO DRAW ON!

LET'S START!

HOW TO DRAW
FIREFLY JAR

1. Start by making a rough outline of the jar. Draw a square for the glass and a rounded top for the lid.

2. Add details to the lid and draw the outline of the latch. Round out the bottom of the jar and remember to erase your guidelines!

3. Continue detailing the lid and latch, drawing parallel to your outline to give the latch shape.

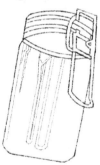

4. Add details inside the jar, including lines for the wire inside. Add details to the glass, as shown. Draw more circular lines on the lid and add detail to the latch.

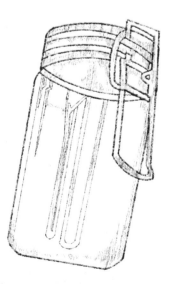

5. Finally, finish by adding shading to the Firefly Jar.

THIS BLANK PAGE IS FOR YOU TO DRAW ON!

LET'S START!

HOW TO DRAW
SHOCKWAVE GRENADE

1. Draw a rough outline. Start with a series of appropriately sized circles.

2. Continue adding detail to each circle and tube. Erase your guidelines to make the sketch cleaner.

3. Add even more circular lines within the appropriate circles. Draw another port at the bottom of the grenade and outline the crystal on the bottom and top.

4. Detail each section. Slowly add detail to the protruding crystals by making them jagged and adding cracks.

5. Finish by adding shading to the shockwave grenade, including to the sides of the crystals and within the tubes.

THIS BLANK PAGE IS FOR YOU
TO DRAW ON!

LET'S
START!

CONGRATULATIONS!

Wow! You made it all the way to the end... Congratulations! You did it!

Now you can draw all your favorite characters and items from these awesome games !

If you enjoyed our drawing book, we would love to hear from you!

Feel free to drop us a review on Amazon and let us know what your favorite thing to draw was.

Thanks a million.

Infinite Kids Press

Congratulations
Drawing Pro:

Date:_____ **Signed:_____**

Made in the USA
Monee, IL
13 December 2021

85246788R00085